How to Draw

Garden Flowers

In Simple Steps

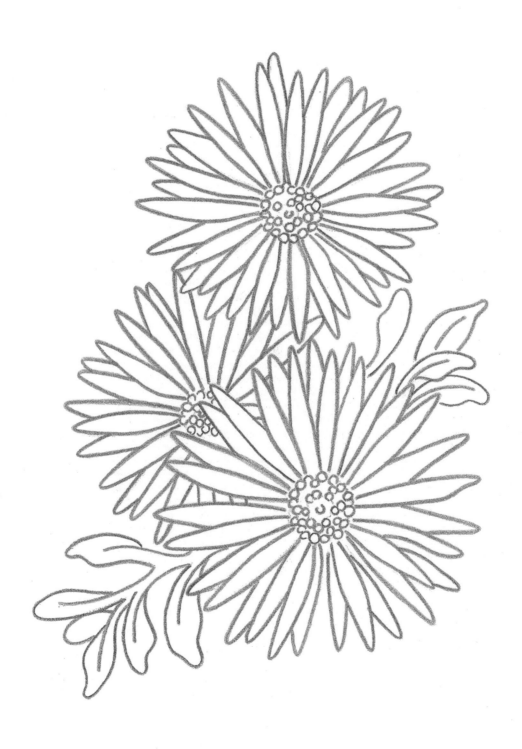

First published in Great Britain 2013

Search Press Limited
Wellwood, North Farm Road,
Tunbridge Wells, Kent TN2 3DR

Reprinted 2015

ISBN: 978-1-84448-879-7

Printed in Malaysia

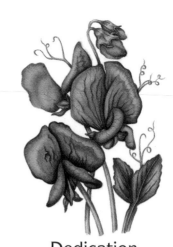

Dedication

To Monica, who loves gardens.

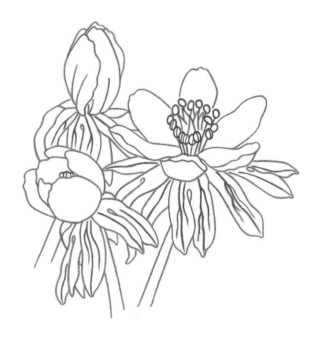

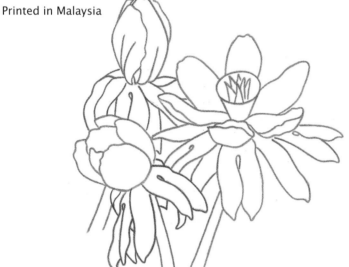

Illustrations

How to Draw

Garden Flowers

In Simple Steps

Penny Brown

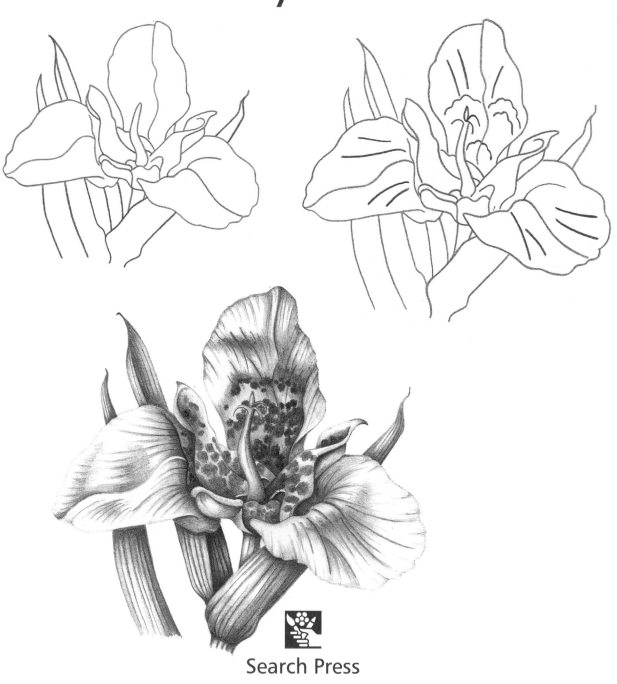

Search Press

Introduction

We are constantly surrounded by flowers in the natural world and the ones
that are most familiar, and most dear to us, are usually garden flowers.
They come in an amazing variety of colours, shapes and forms making them
wonderfully inspiring subjects for artists. The huge variety of flowers, however,
can be daunting and the majority of blooms do look too complex to be drawn
successfully.

This book helps you to approach the subject in an easy and successful
way. By breaking down the process into simple steps, it smoothes away the
complexity and shows how each stage can be developed into beautiful finished
pictures.

I have chosen twenty eight species, from the delicate sweet pea and colourful
dahlia to the more exotic quince and tigridia. Each flower starts with the angles
of the bloom and simple geometric shapes. Later drawings are developed with
the addition of petals, then second flowers, buds, stalks and leaves. Details,
such as stamens, are drawn in during the final line stage when the basic
structure of the flower is complete.

In the sequences, I have used a grey coloured pencil for the first stage and,
subsequently, previous shapes and lines are drawn in using brown; any new
features are added in grey. This method of drawing clearly shows how each
image is developed, making it easy for you to follow the stages.

When copying the preliminary sequences use a soft pencil (HB, B or 2B) and
do not press too hard on the paper, then it will be easy to remove unwanted
marks.

The penultimate step is the tonal pencil drawing. This is a study of the effect
of light and shade on the flowers. These elements are important in a drawing,
because they create the three dimensional effects that cause the subject to
spring to life. For the tonal drawing start with a harder pencil (2H or H), and
when you are working on the really dark areas build up to a 4B or 6B.

The last drawing is in colour, and this should always reflect the tonal values
of the light and shade study. I have used watercolours for the final images, but
pastels, coloured pencils or acrylics will all give good results.

The main skill you need for drawing is observation. The more closely
you observe your chosen subject, the better it is because you will start to
understand how it is constructed. A deeper understanding will lead to better
pictures, and if you develop your drawing skills using the methods in this book,
you will soon be able to draw your own pictures.

Happy Drawing!

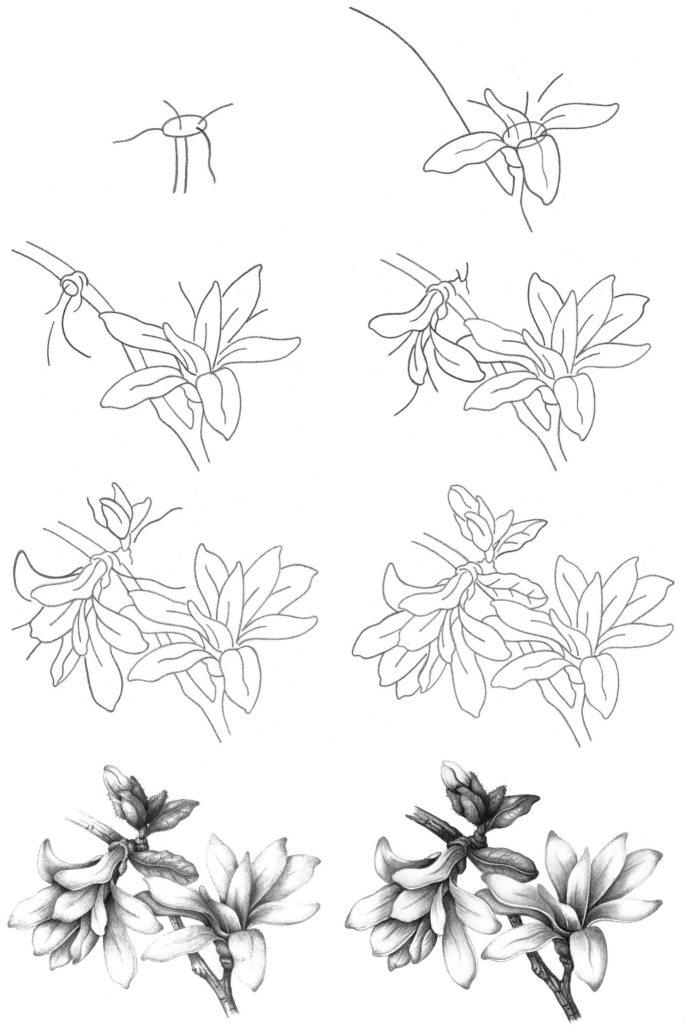

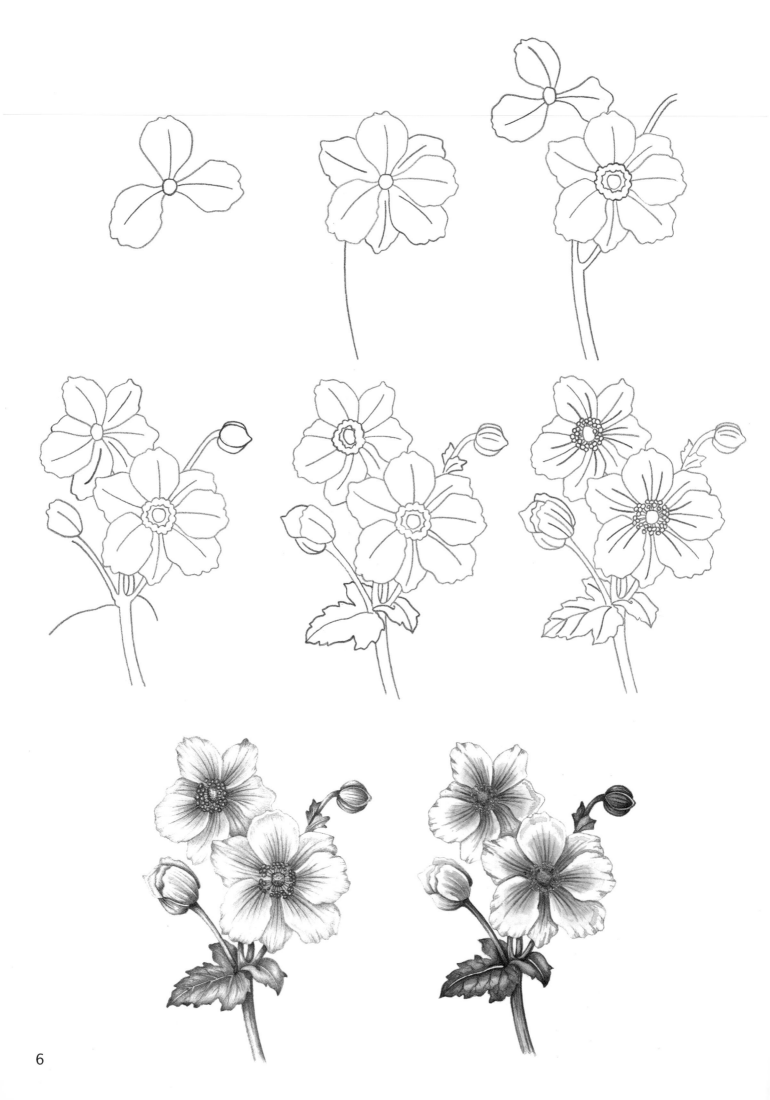

6

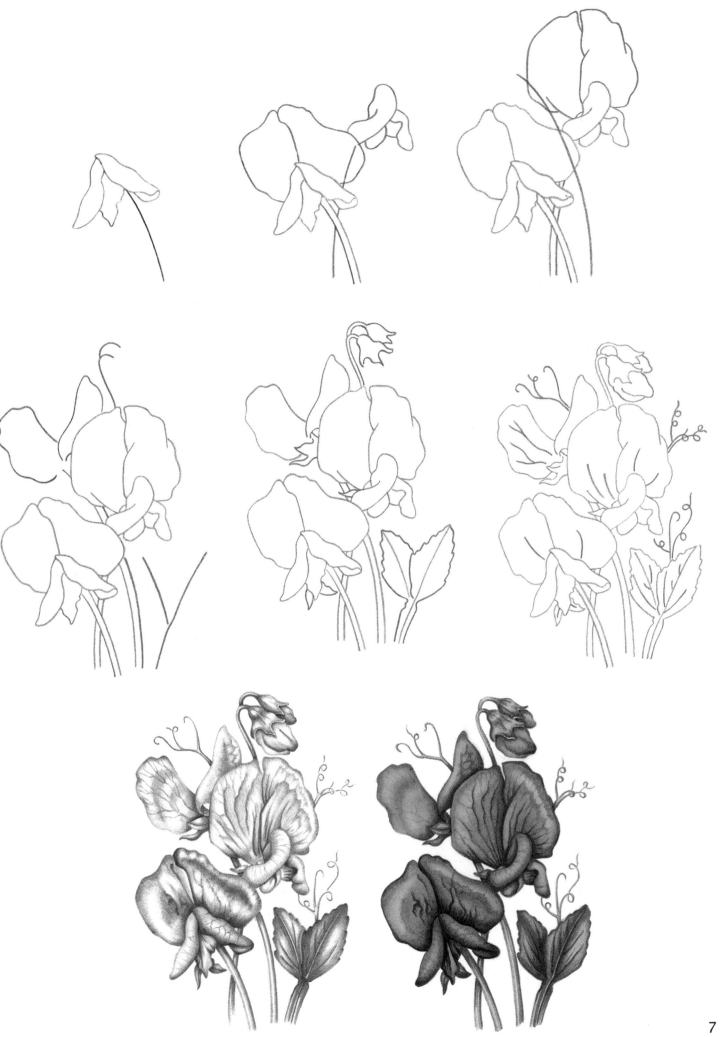

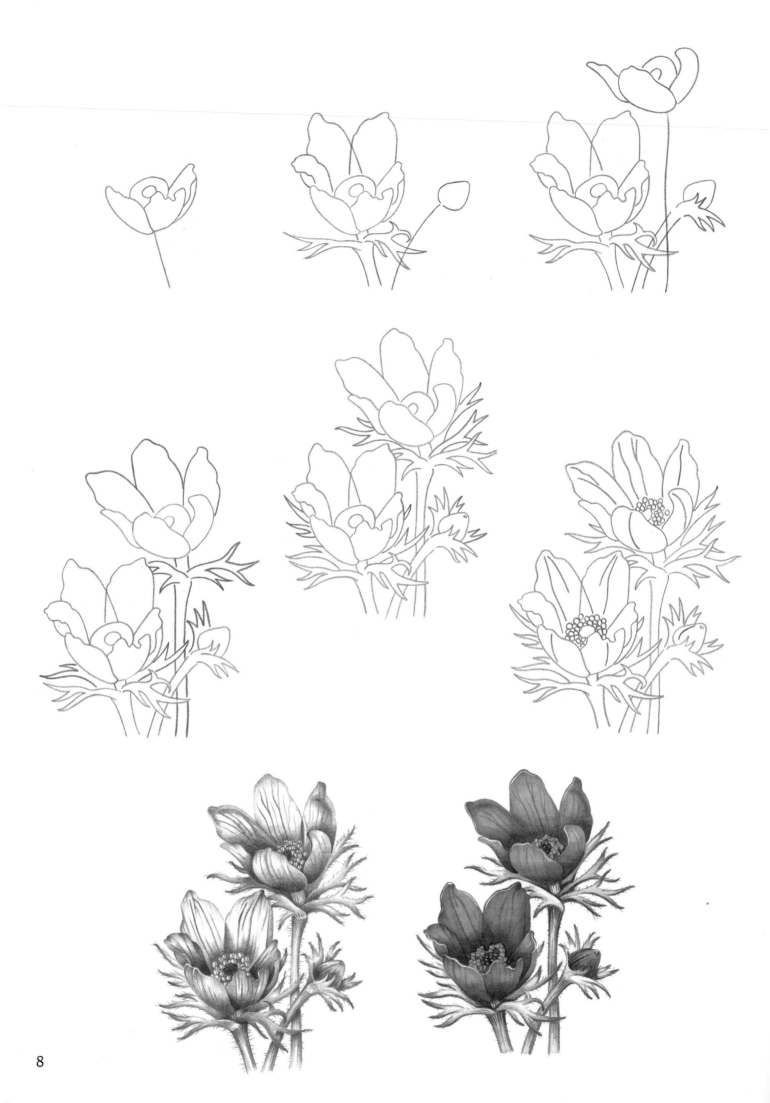

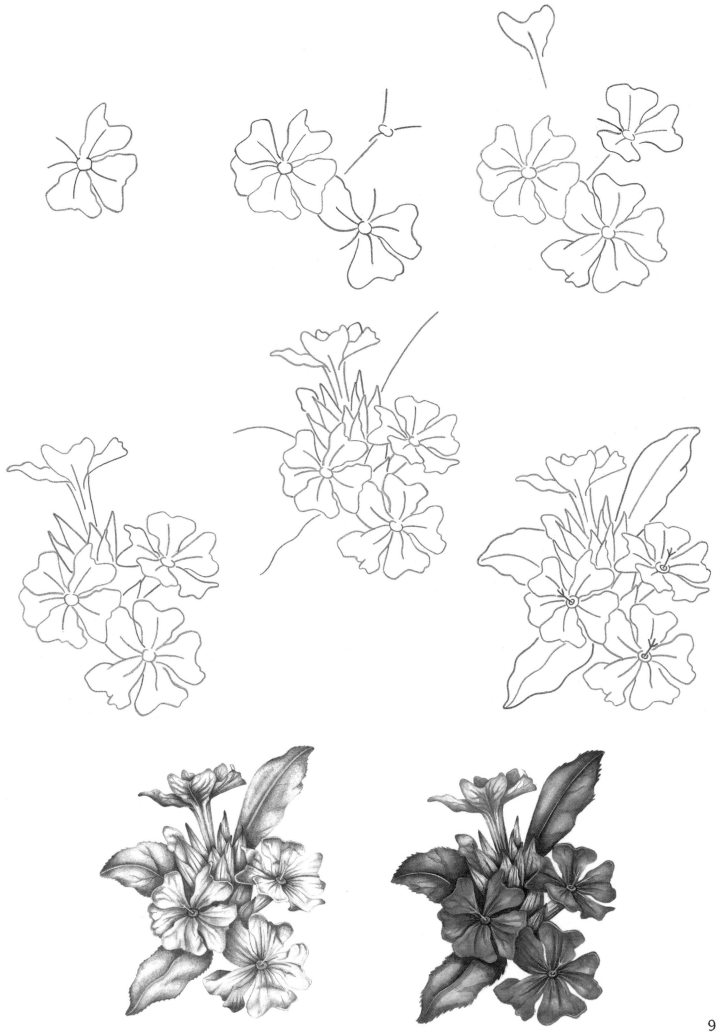

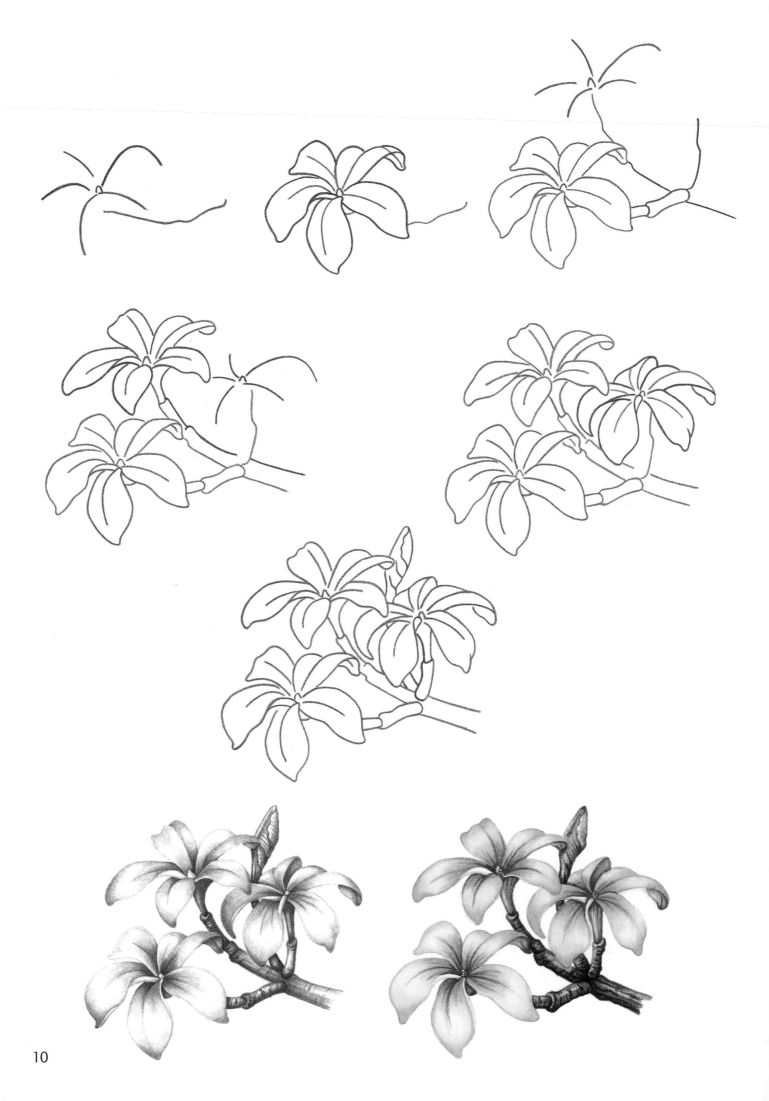

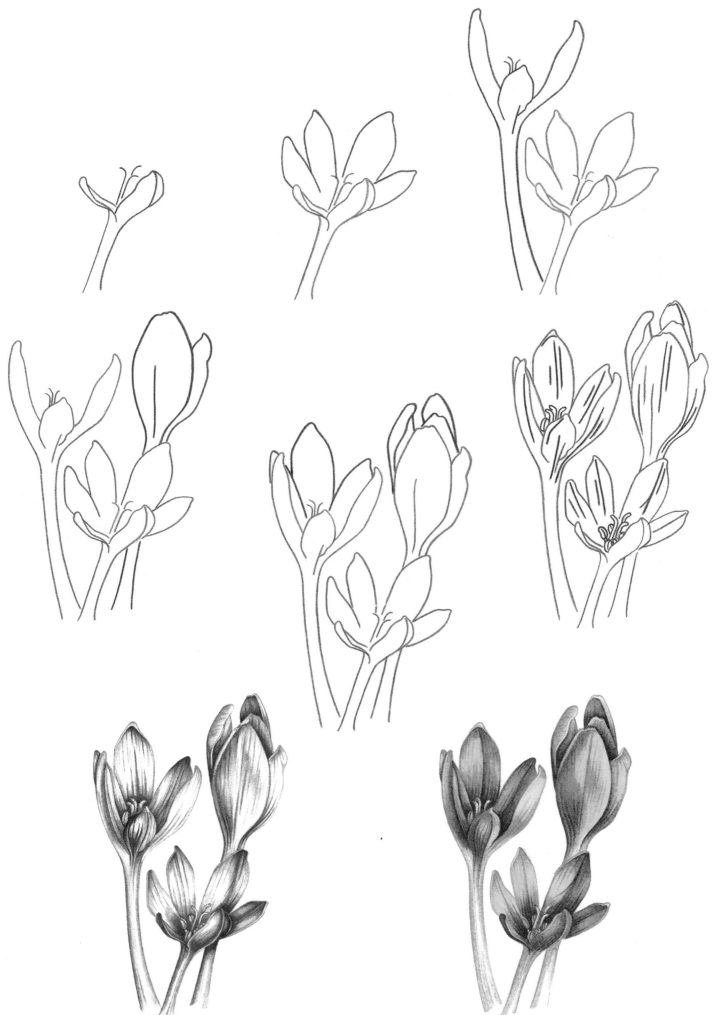

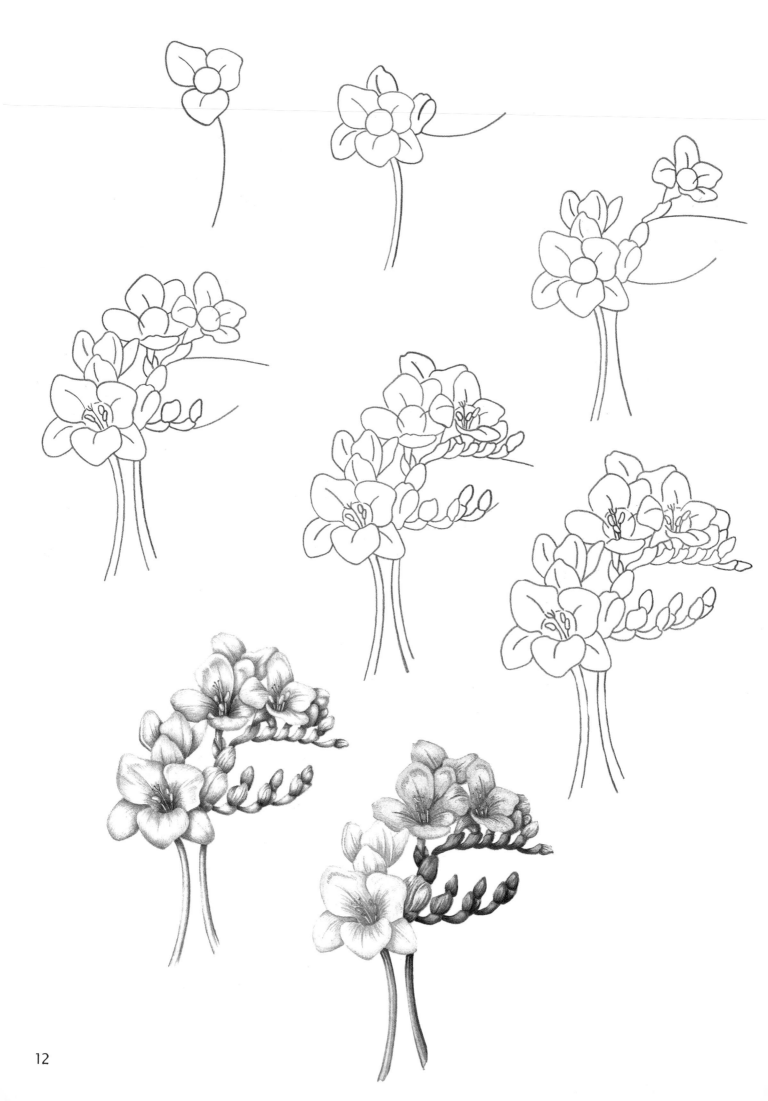

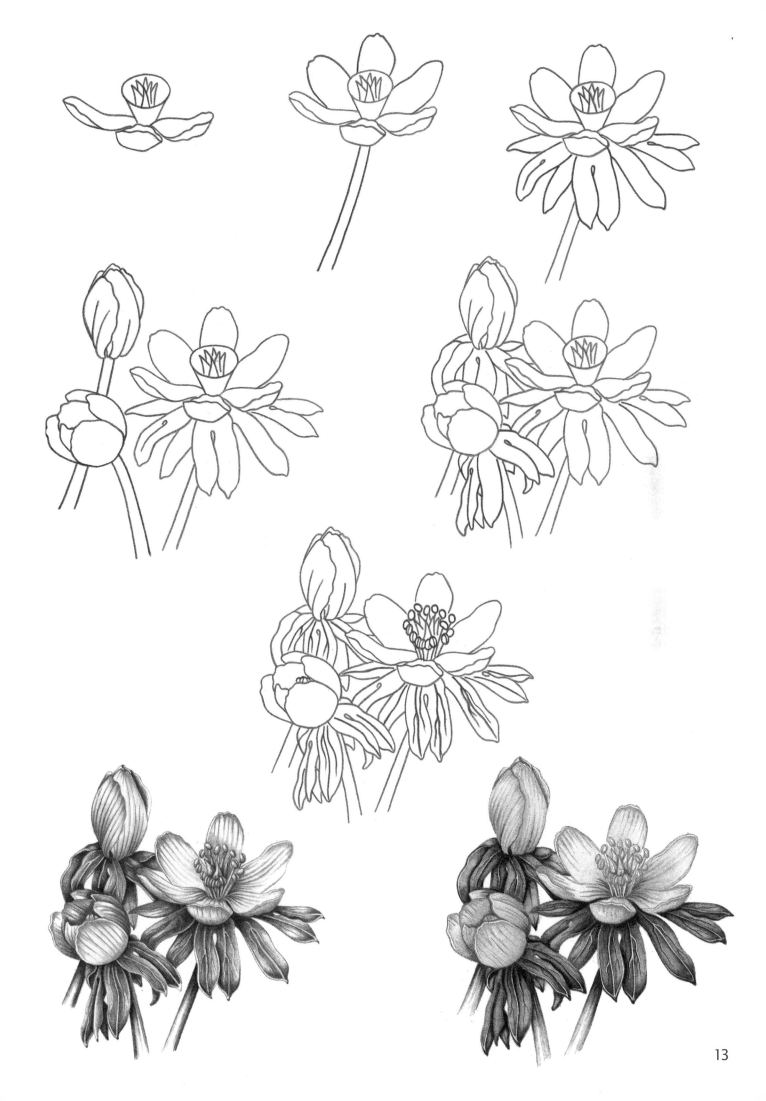

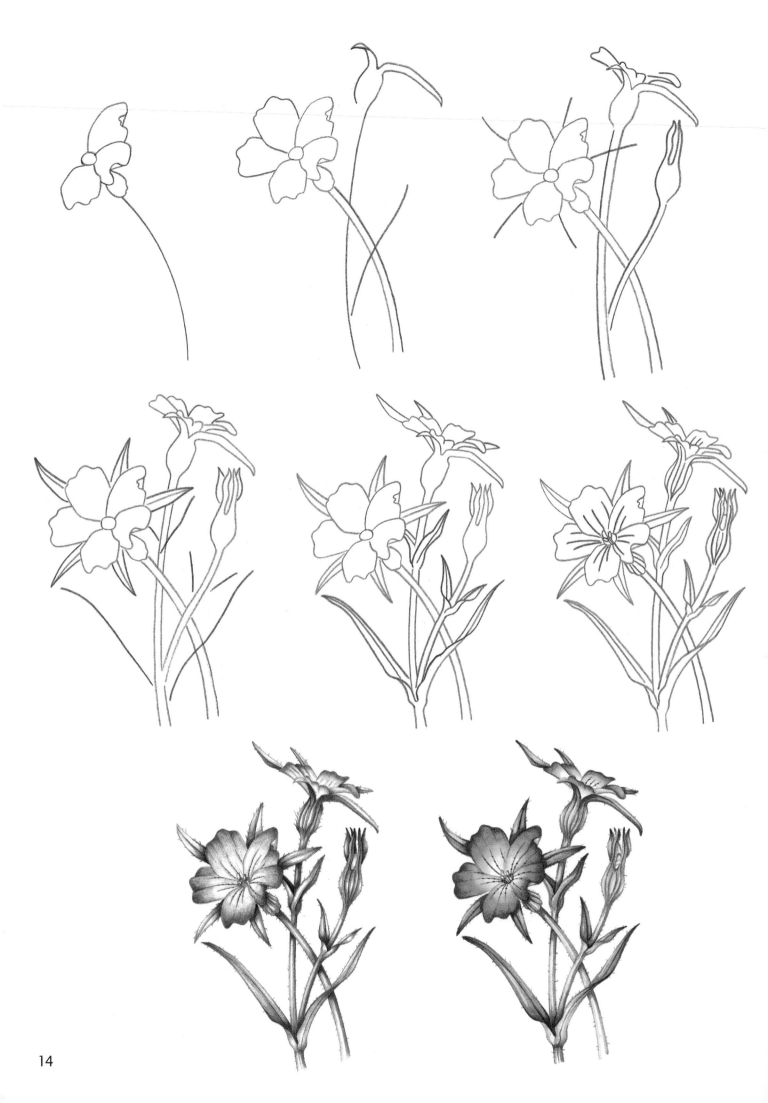

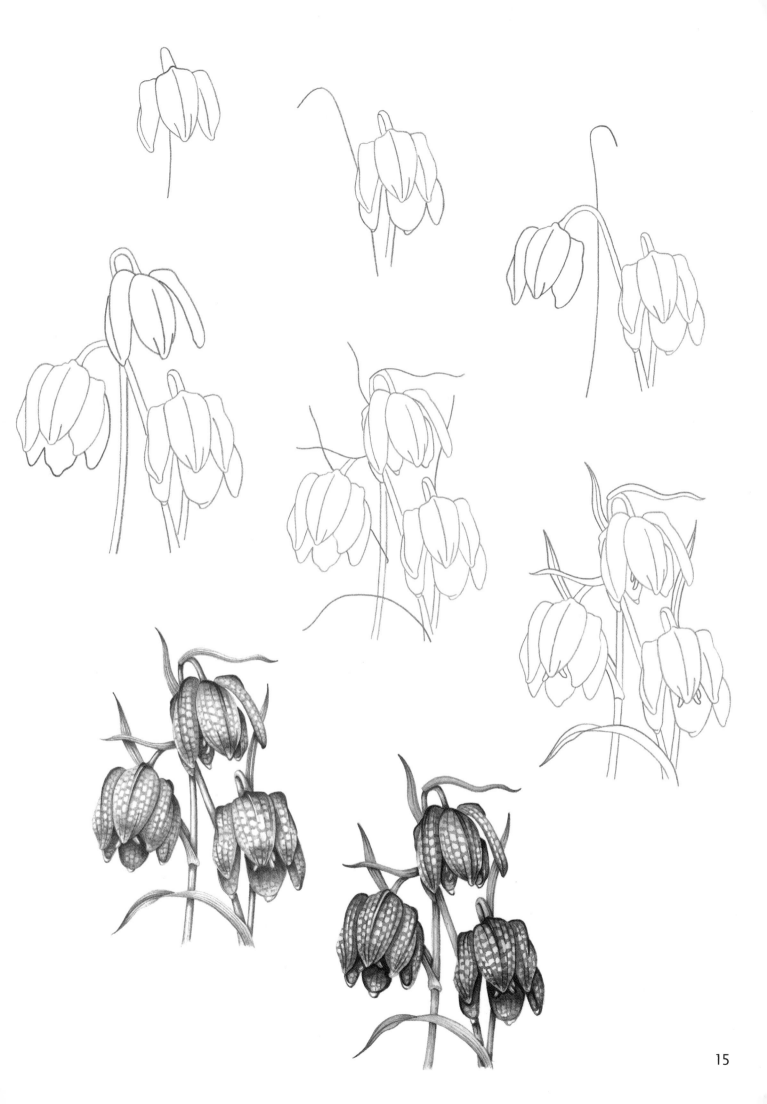

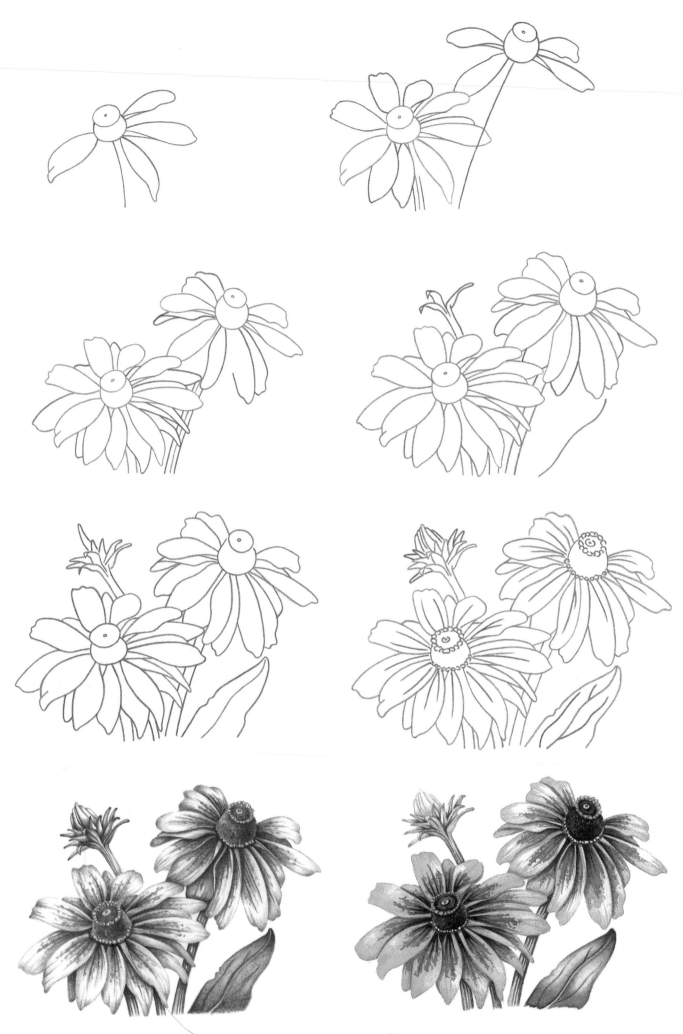

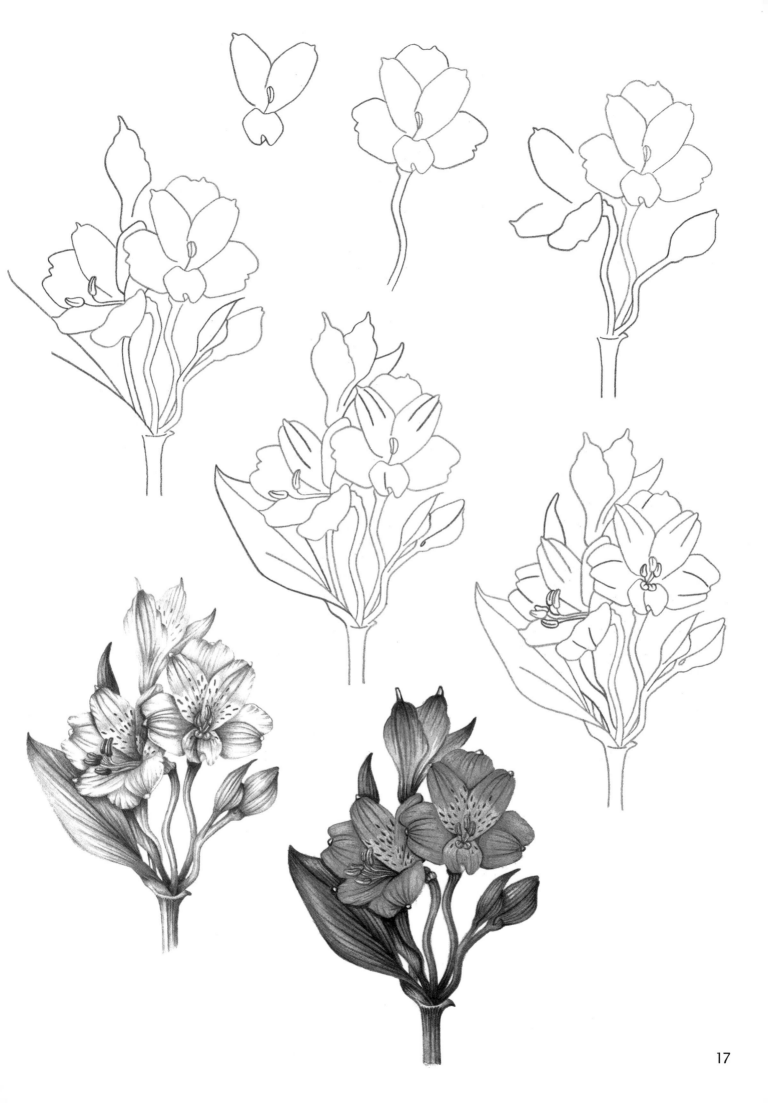

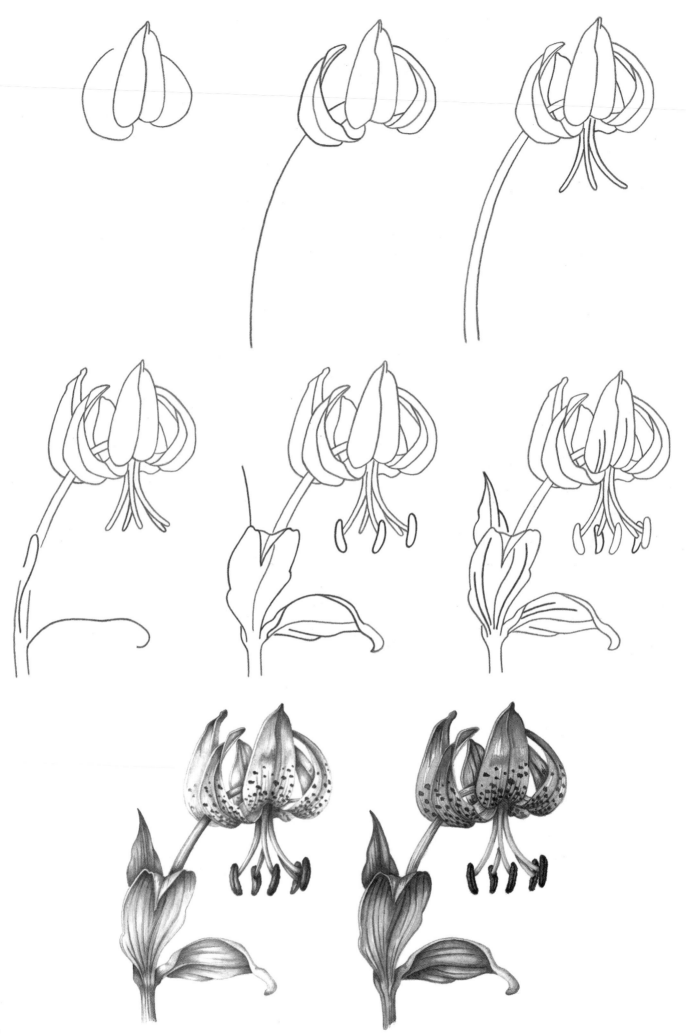

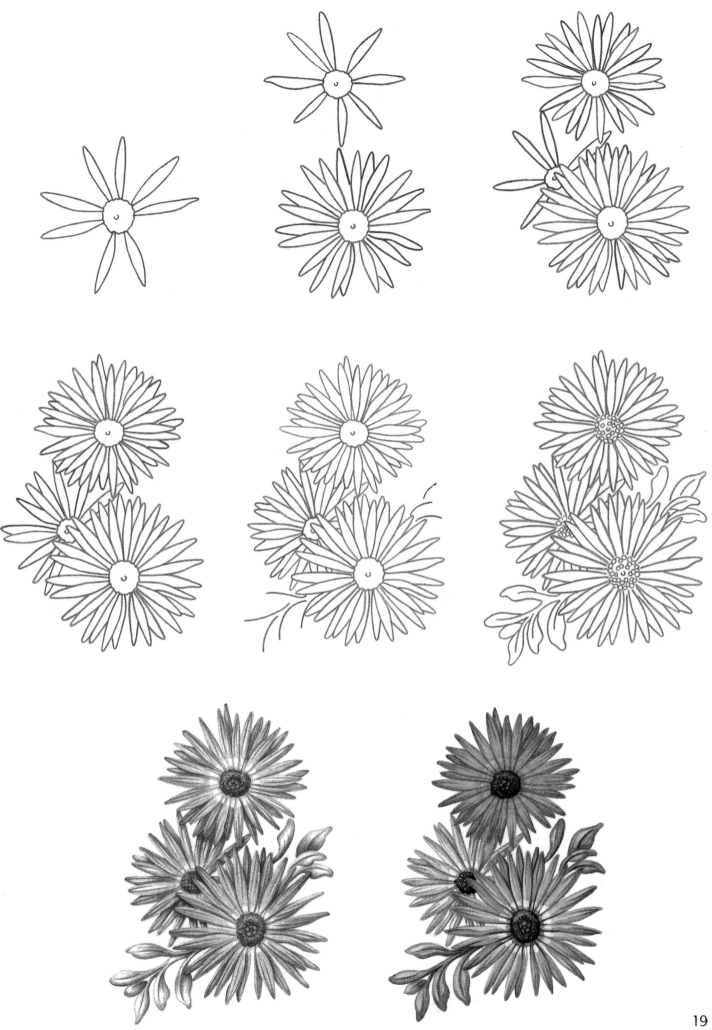

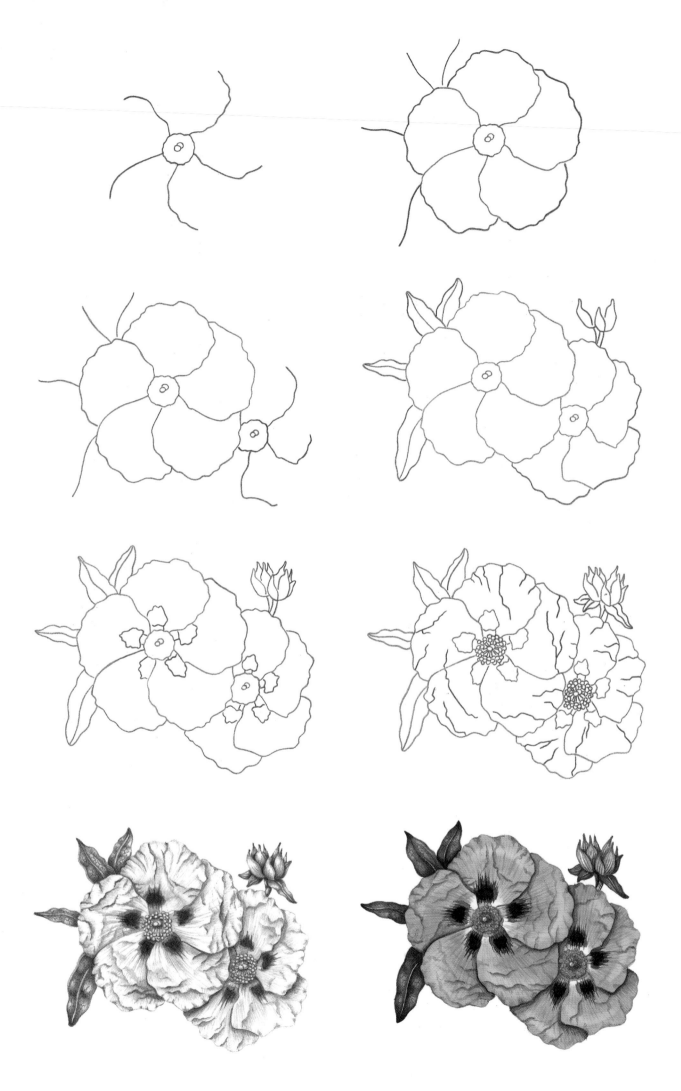

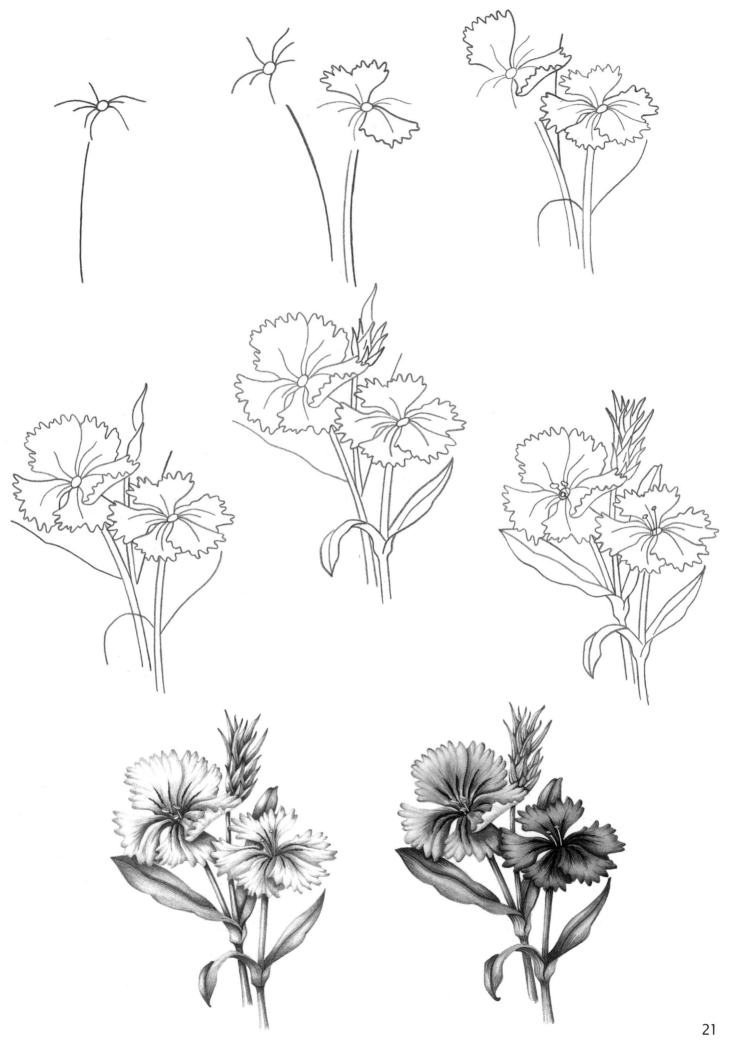

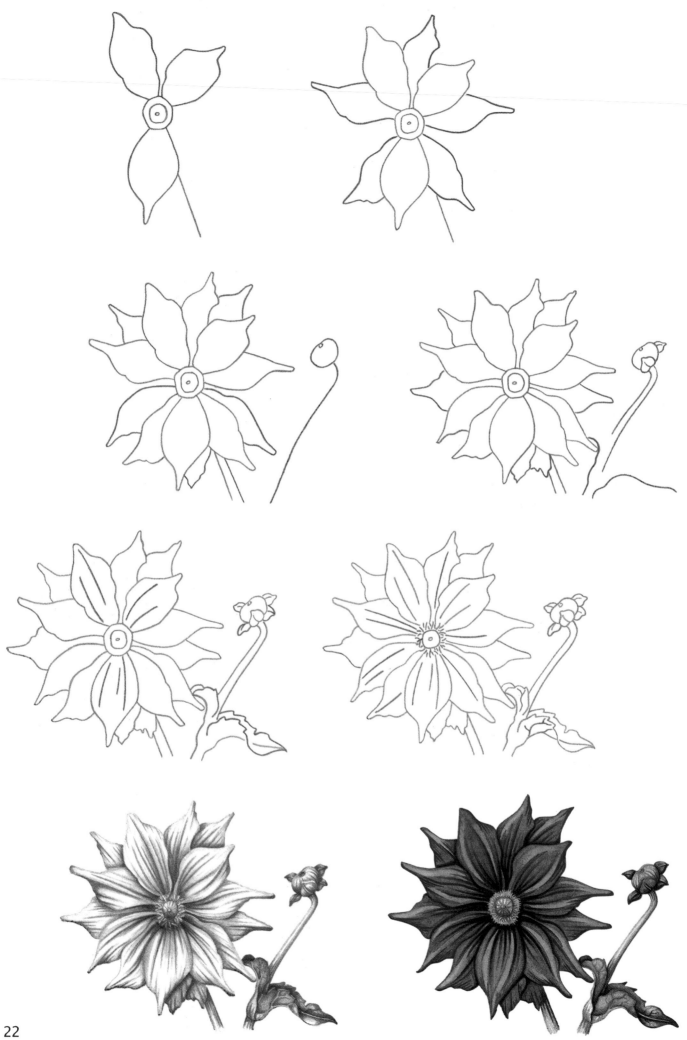

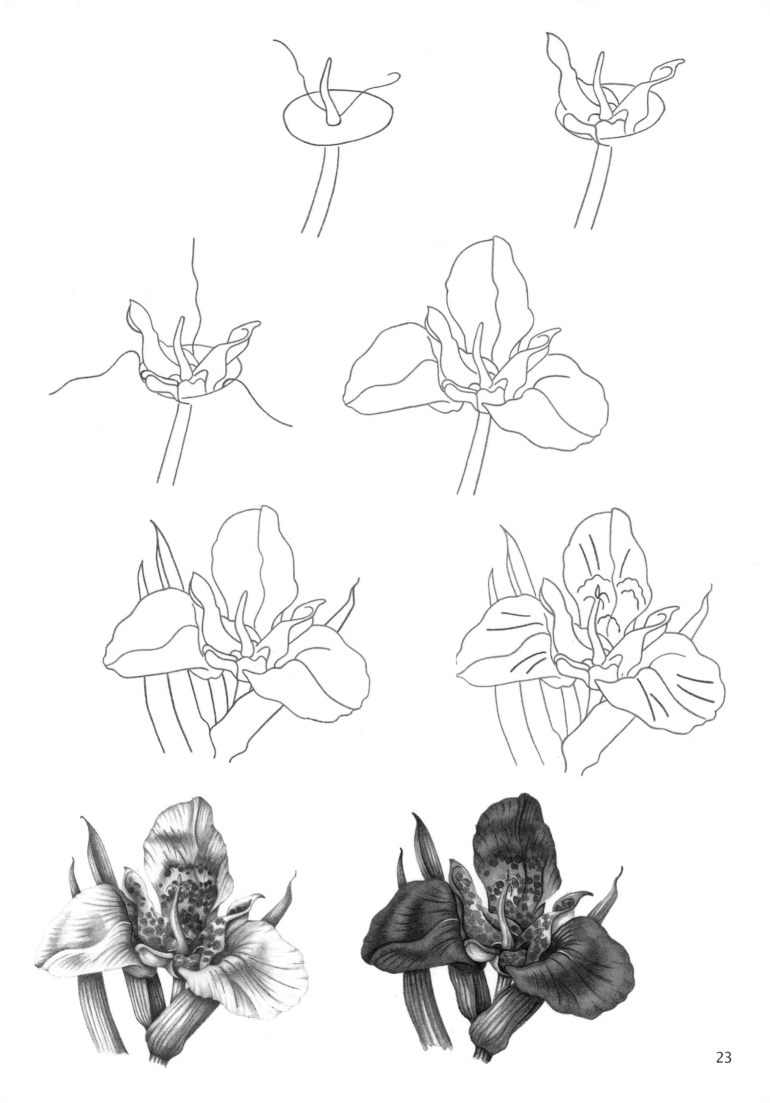

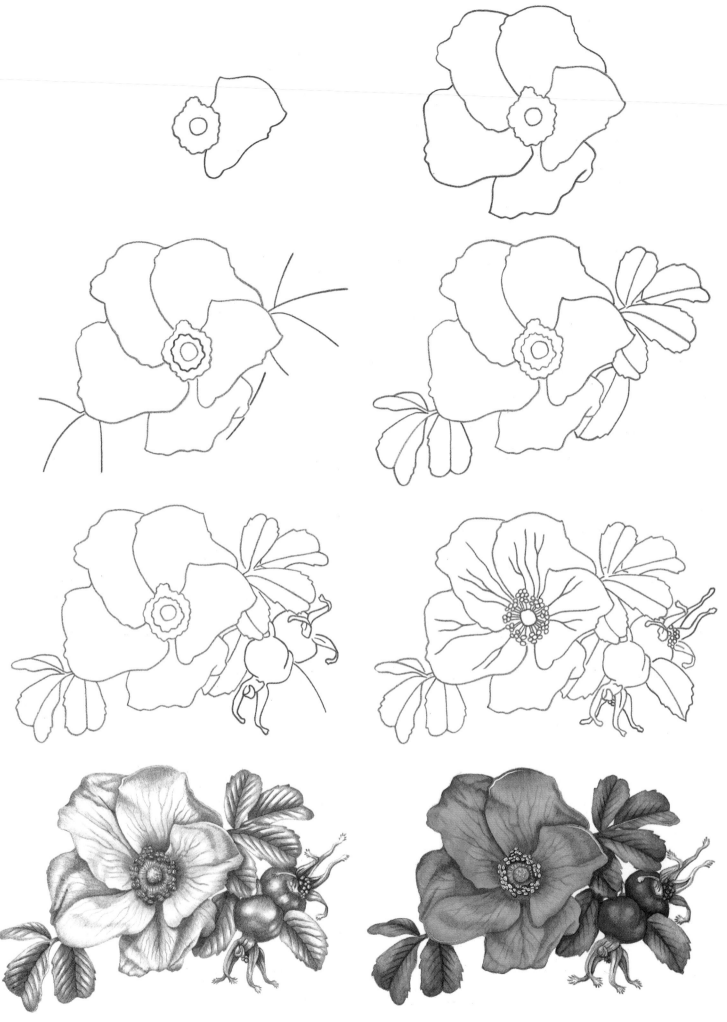

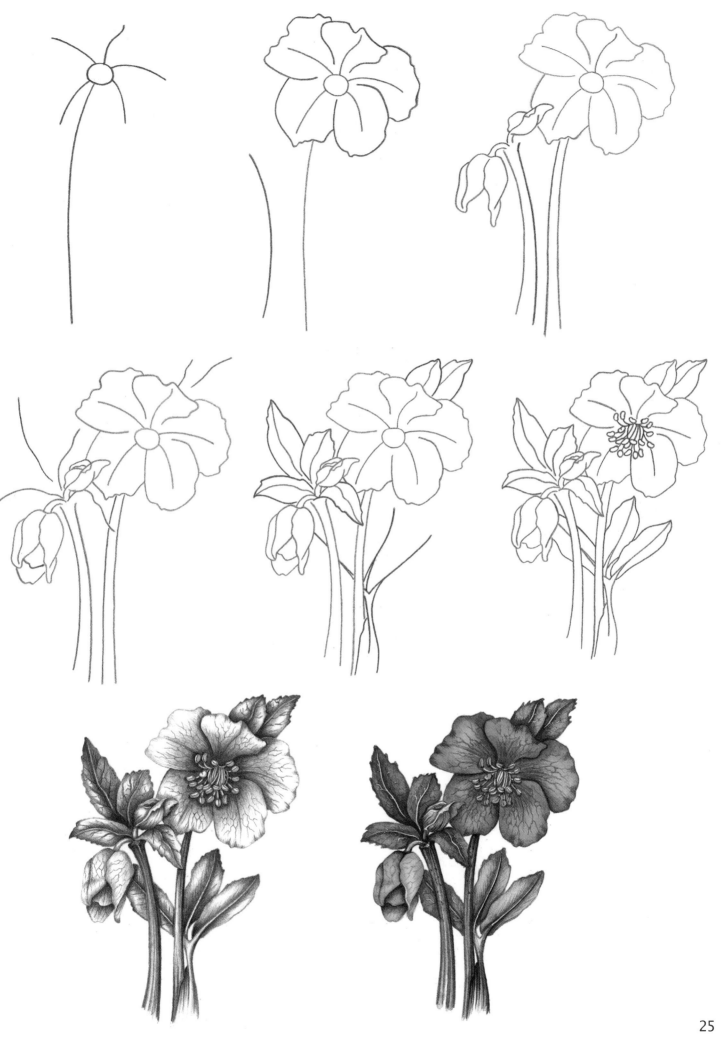

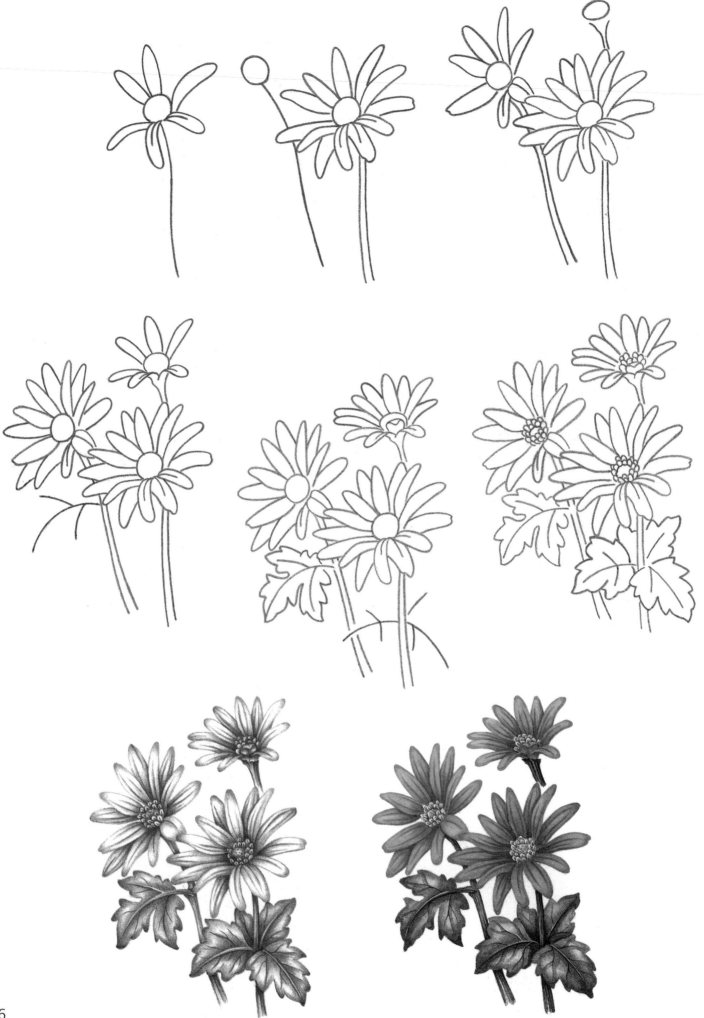

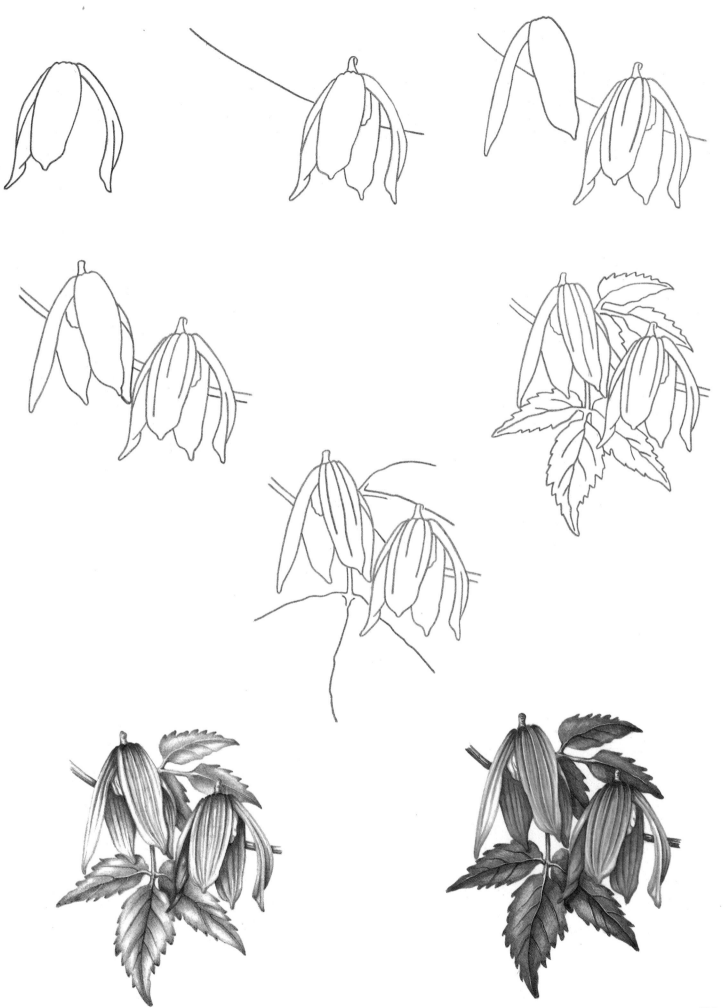

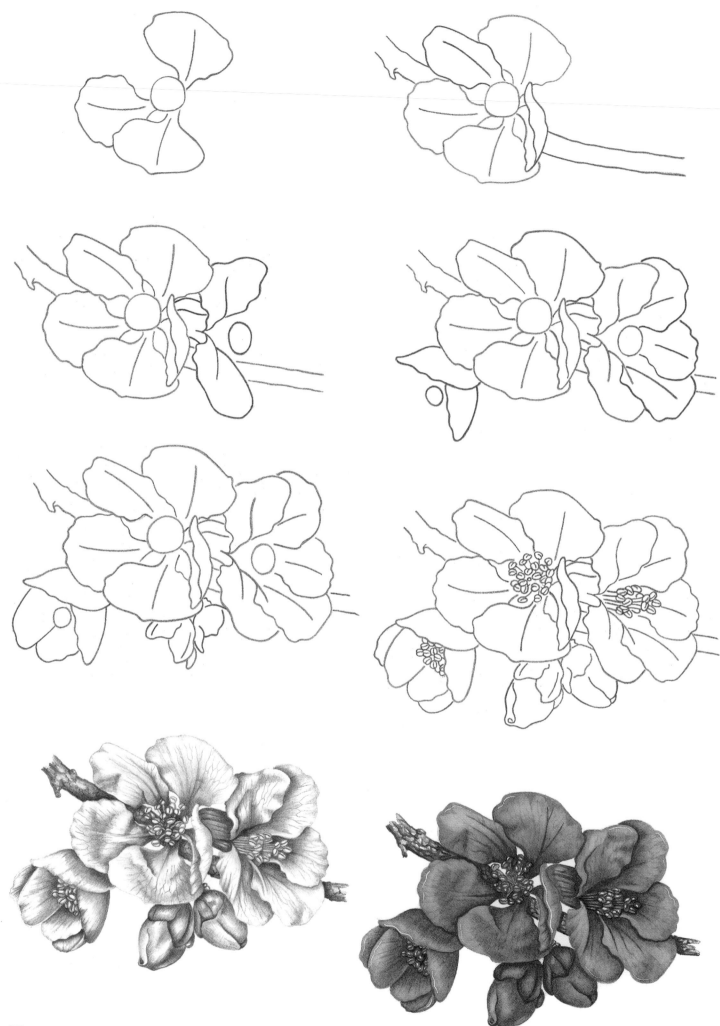

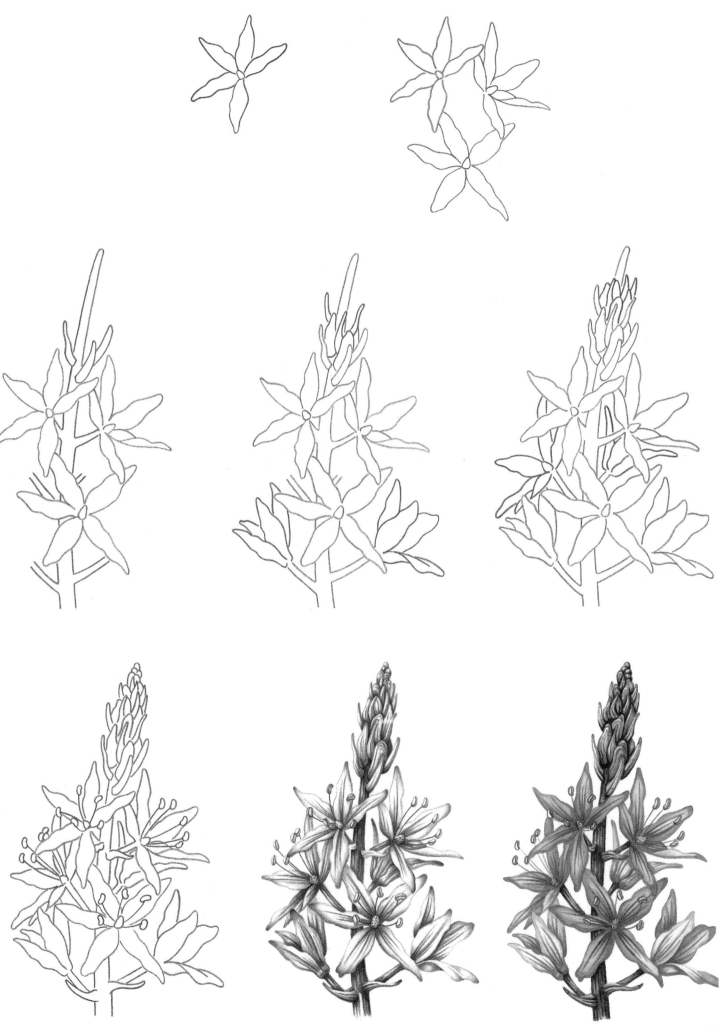

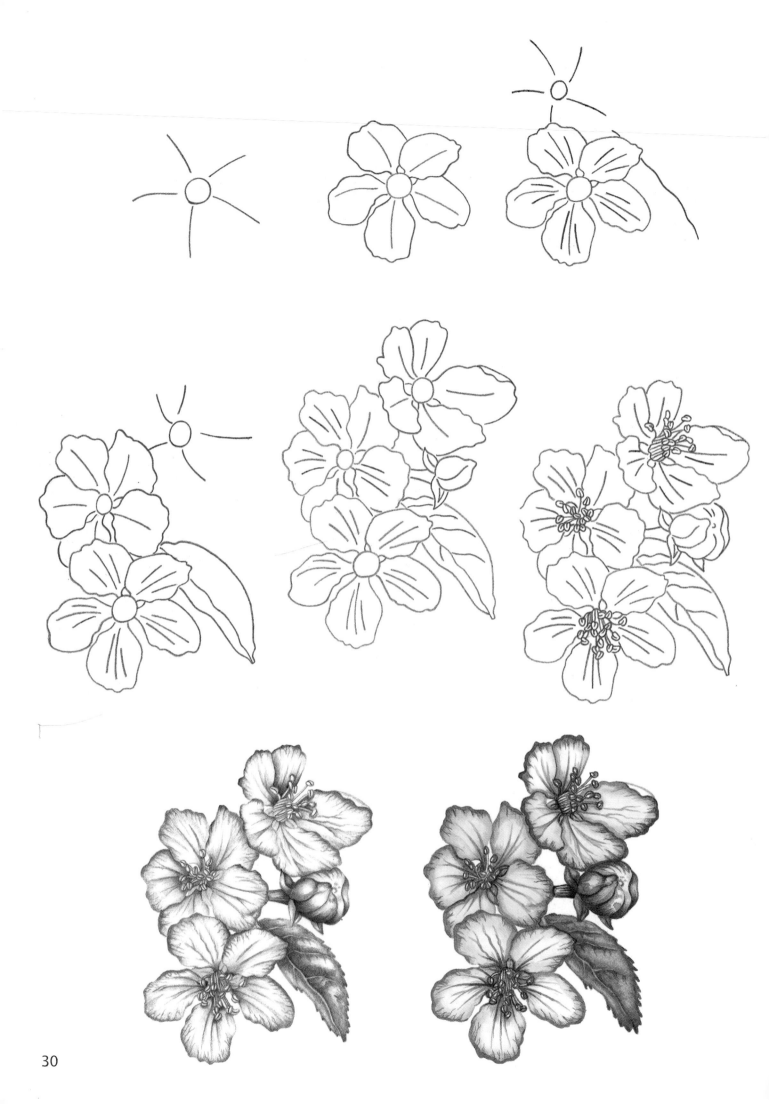

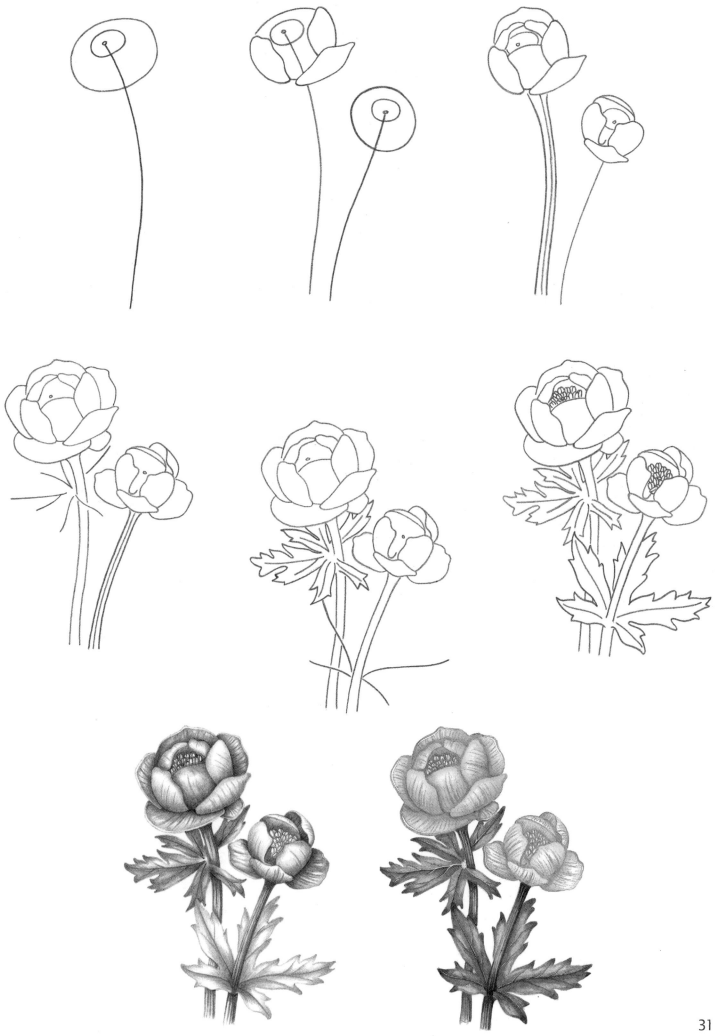

31

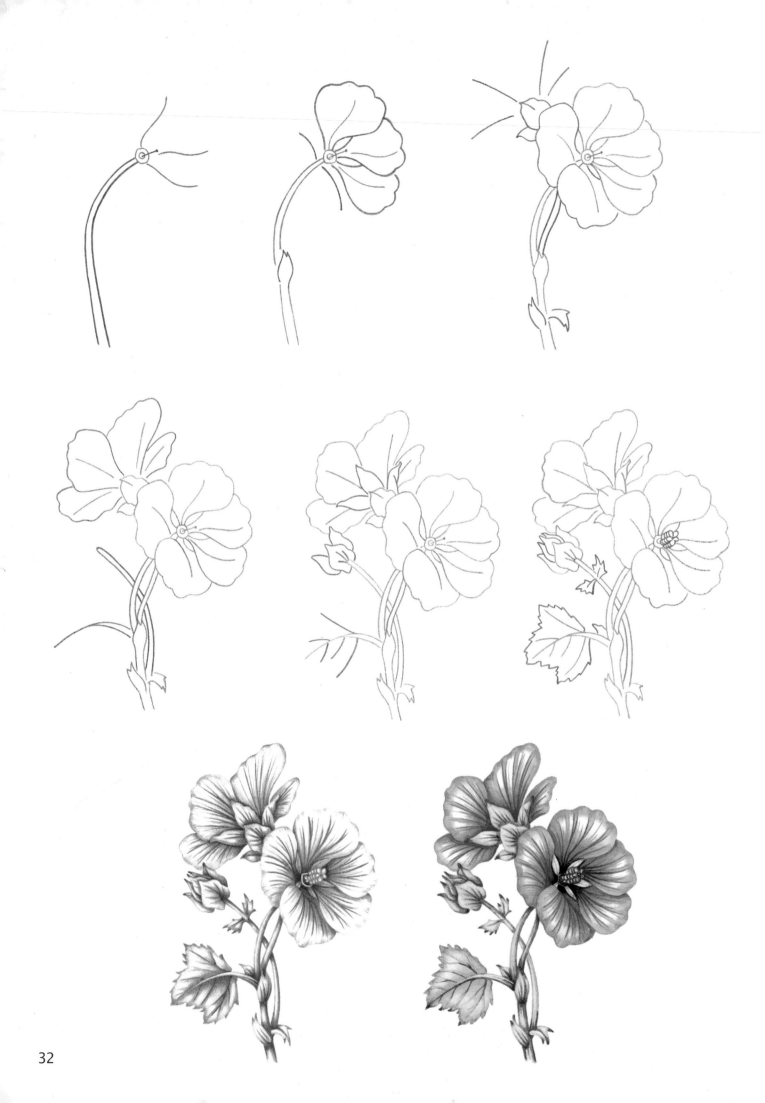